DEEP-SEA VENTS

Living Worlds Without Sun

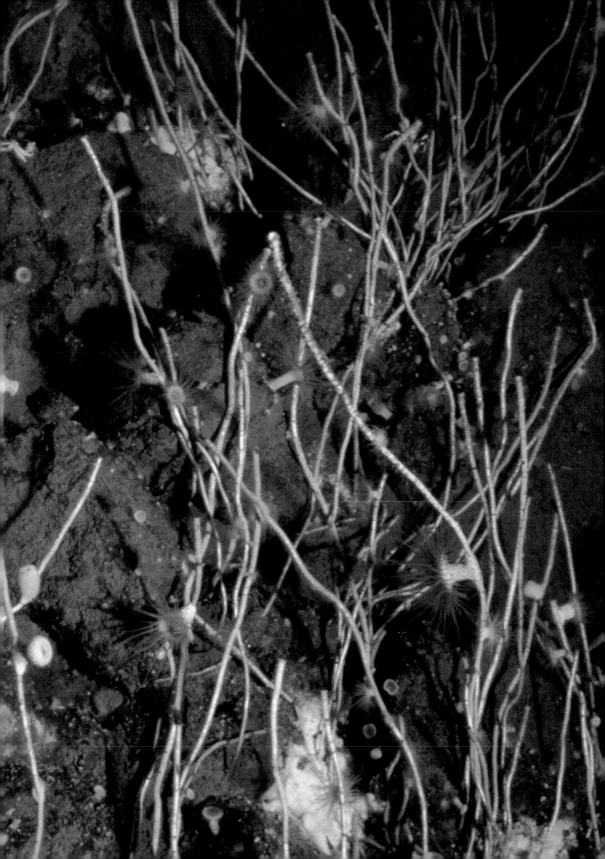

DEEP-
SEA
VENTS

Living Worlds Without Sun

JOHN F. WATERS

Illustrated with Photographs

COBBLEHILL BOOKS
Dutton New York

To my wonderful wife, Barbara . . . my best friend.

PHOTOGRAPH CREDITS: U.S. Geological Survey, R. Holcomb, 23 (bottom);
R. Koski, 33; courtesy of W. R. Normark, 32 (top); J. Slack, 24; R. E. Wilcox,
14. Cindy Lee Van Dover, ii, 10, 12, 17 (bottom), 19, 22, 30, 34 (bottom),
36, 42, 44. John F. Waters, 17 (top). Woods Hole Oceanographic Institution,
23 (top); Robert Ballard, 29; John Edmond, MIT, 28, 32 (bottom); Dudley
Foster, 34 (top); Robert Hessler, 37; CNEXO/WHOI, Jean-Louis Michel, 43; John
Porteous, 46; Fred Speiss, 25; Geoff Thompson, 38.

Library of Congress Cataloging-in-Publication Data
Waters, John Frederick, date
Deep-sea vents : living worlds without sun / John F. Waters.
 p. cm.
Includes index.
Summary: Describes the discovery and investigation of openings in the ocean
floor where heated water escapes and examines the new life forms and other
phenomena that have been found there.
ISBN 0-525-65145-4
1. Hydrothermal vents—Juvenile literature. 2. Hydrothermal vent ecology—
Juvenile literature. 3. Hydrothermal vent fauna—Juvenile literature.
[1. Hydrothermal vents. 2. Oceanography. 3. Marine biology.] I. Title.
GB1198.W35 1993
551.46′08—dc20 92-41111 CIP AC

Published in the United States by Cobblehill Books,
an affiliate of Dutton Children's Books,
a division of Penguin Books USA Inc.,
375 Hudson Street, New York, New York 10014

Designed by Mina Greenstein
Printed in Hong Kong
First Edition 10 9 8 7 6 5 4 3 2 1

Acknowledgments

I am grateful to the following persons and institutions for their wonderful help in the preparation of this book:

Nancy Green, Former Public Information Officer, Woods Hole Oceanographic Institution; Joseph Cone, Instructor, Oregon State University; Geoff Thompson, Woods Hole Oceanographic Institution; and special thanks to Dr. William Normark, U.S. Geological Survey, Menlo Park, California, who answered my many questions and provided photographs.

And a very special thank-you to Dr. Cindy Lee Van Dover of the Woods Hole Oceanographic Institution for the use of her wonderful photographs and taking the time to tell me all about the new and exciting life in the deep sea.

Contents

1

An Astonishing Discovery

The oceans of the world have always fascinated people. Just what was down there in the murky depths? The earliest divers were curious and ventured down as far as they dared. They quickly encountered extreme pressure and cold and darkness. Only in recent years have scientists been able to dive to the deepest depths of the mighty oceans, using tiny undersea vehicles called *submersibles*. What they have found is startling. The scientific world has been excited about it ever since.

Even before submersibles, a great deal had been learned about the oceans. Oceanography—the study of ocean basins and shores and the characteristics of ocean waters—dates back to the 1870s. Over the years numerous expeditions were sent out, contributing to the knowledge of the oceans. It was established that the ocean floor is far more rugged than had been supposed. Marine geologists studied the movement of the plates that make up the Earth's crust.

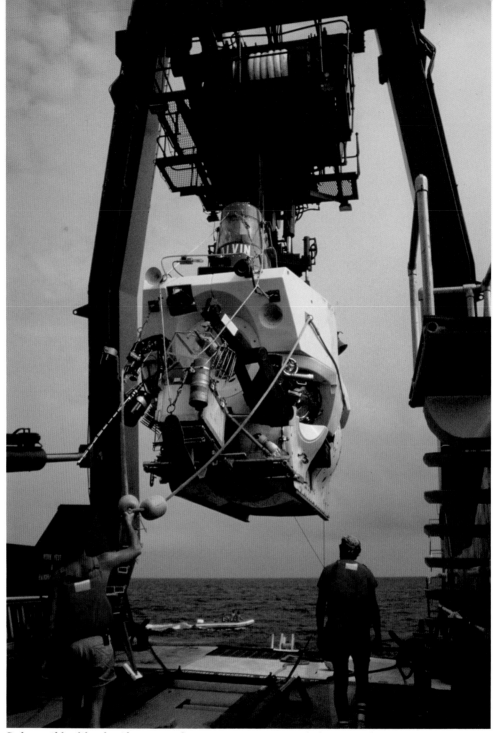

Submersibles like the Alvin, *seen here on its support vessel the R/V Atlantis II, have made it possible for scientists to dive to the seafloor.*

Some scientists believed that every part of the sea bottom was cold, but by the mid-1960s geologists predicted that there might be hot spots at certain areas. The Earth's core is molten lava, and when the plates of the Earth's crust separate, the molten lava, or magma, fills in the space.

In 1977, divers descending at a site in the Galápagos Islands found not only hot spots—hydrothermal vents—but a completely new and different form of life there in the deep ocean. The new form of life does not get its energy from the sun, as all other life forms on Earth do. The energy source, working through bacteria, comes from chemicals that are deep within the Earth. The astonishing discovery was considered the greatest in the last one hundred years of deep-sea biology.

The reason the new life form had been hidden away from curious eyes for so long is simple. It is because the oceans are so vast. They cover nearly 71 percent of the Earth's surface, and oceans are very deep. The average depth of all oceans is more than two miles, about 12,500 feet (3,810 meters). All in all, there are 331 million cubic miles of water in the world. Only in recent years has it been possible to go exploring such depths. It is not surprising that a totally different kind of life would be hidden away for so long.

The World Beneath the Sea

Almost everyone is familiar with the Earth on the surface. There are flat lands, sloping hills, tall mountains. There are deep gorges, canyons, and valleys. There are lakes and rivers and ponds, and all kinds of rocks, sand, and soil. Much of the land is covered with green plants.

Most people only know what is beneath the waves if they drop

an anchor from a boat until it hits bottom, or if a fishing line strikes the bottom maybe a few hundred feet down. Scientists, however, have a good idea of what the seafloor is like. By using sonar, underwater cameras, and making dives in submersibles, they know that it is similar to the land surface. There are hills and mountains, rocks and sand and fine material called silt. There are shelves, and ridges, and slopes, and rifts.

Continental shelves drop away from the shores, tilting downward 250 to 600 feet (76 to 183 meters), though some drop off as much as 1,700 feet (528 meters). Most of the shelves are relatively

Tube worms found at vent sites are new life forms, existing without sunlight.

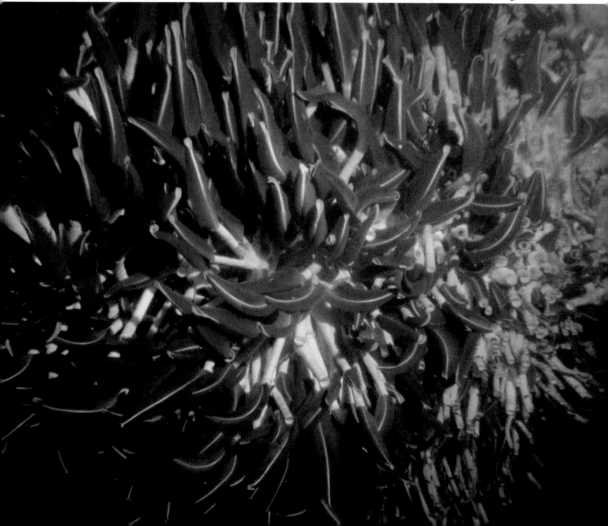

shallow—100 to 300 feet (30 to 91 meters)—and since sunlight filters down, it is where most of the ocean life lives. After the shelves come the continental slopes. They are very sharp and form the "walls" of the ocean basins.

The Abyss

All of the deep sea—the vast deep area that begins at the bases of the continental shelves—is known as the *abyss*. Because no sunlight reaches any part of it, the abyss is completely dark and very cold and no plants grow there. Some parts of the abyss vary from 10,000 to 30,000 feet (3,048 to 9,144 meters) below the ocean surface.

Water has tremendous pressure that increases with depth. Anyone picking up a bucketful of water knows that water is very heavy. Imagine the weight of water on anything 30,000 feet down, a distance of almost six miles. Water cannot be compressed and anything in the deep sea is squeezed on all sides by the pressure or weight of the water.

It is rugged territory down in the abyss. There are tall mountains, some flat-topped, others sharply peaked. There are valleys and canyons, mid-ocean ridges, and submarine trenches as much as seven miles below the surface water. Undersea mountains form the Mid-Ocean Ridge. This ridge is an undersea mountain range that runs around the globe under the oceans and splits the ocean floor into basins.

There is considerable movement because of the plates that make up the Earth's crust. The crust is not one solid piece of material. It is made up of moving plates called *tectonic plates* that ride along on a partly molten layer called the *asthenosphere*. The plates slide sideways, dip under one another, or pull apart. As the Earth's gigantic plates separate, magma from beneath the crust wells up to

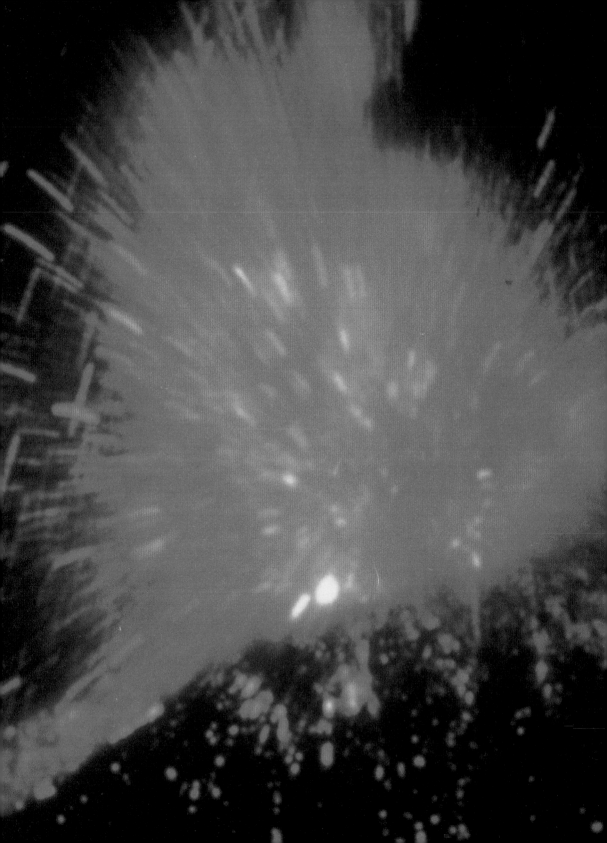

fill the space. The magma creates new ocean crust and as it cools in the frigid water, the new crust develops cracks and fissures into which seawater seeps. The tremendous heat and pressure of the magma within the Earth cause this water to leach minerals from the rocks. As the water is forced back up to the seafloor, it bursts through vents.

Underwater cameras have provided evidence that there is fire beneath the sea. In the form of hot lava, it has much to do with the constant changing of the Earth. The moving plates cause earthquakes and faults and volcanic activity. When surface volcanoes erupt, rivers of lava flow down the sides, or lava is shot up into the air. Undersea volcanoes erupt with equal force, but the lava cools quickly in the cold water and hardens almost in place. Once hardened, the lava looks like giant pillows and is called *pillow lava*. An undersea eruption produces ash and steam, and sometimes black clouds, although the pressure underwater often keeps steam and gas in solution.

Night view of red-hot lava bursting above the crater rim of the volcano Parícutin in Mexico.

2

Project
FAMOUS

Firsthand information about the bottom of the sea had its beginnings with early deep-sea divers like Dr. William Beebe. Beebe made many dives in his bathysphere. In 1934 he reached a record depth of 3,028 feet (923 meters). He was excited at seeing life in the deep, deep sea for the first time. Scientists were excited to know that someone could go into the harsh environment of the deep sea and return safely.

With Beebe and others detailing through the years that there are great things to see and much to learn about the sea bottom, several governments met in 1967 and discussed funding a series of dives to an area of the Mid-Atlantic Ridge. Planning took several years, but in 1974 France and the United States agreed on Project FAMOUS (French-American Mid-Ocean Undersea Study). One skeptical scientist who doubted that anything of real scientific worth would come out of so many expensive dives said that the sub-

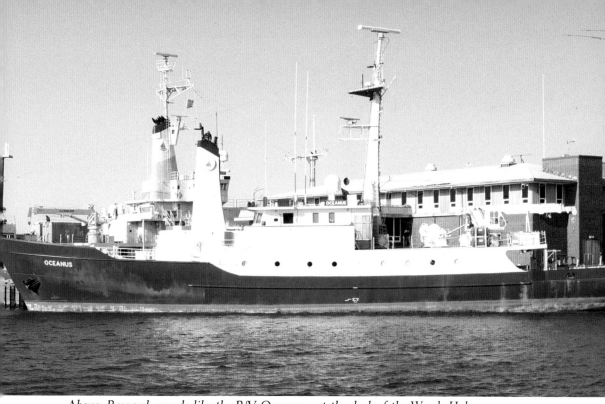

Above: Research vessels like the R/V Oceanus, *at the dock of the Woods Hole Oceanographic Institution, provide information about the ocean floor.*

Below: A submersible needs a mother ship for transportation to and from a dive site. The Lulu *was the* Alvin's *mother ship for some expeditions.*

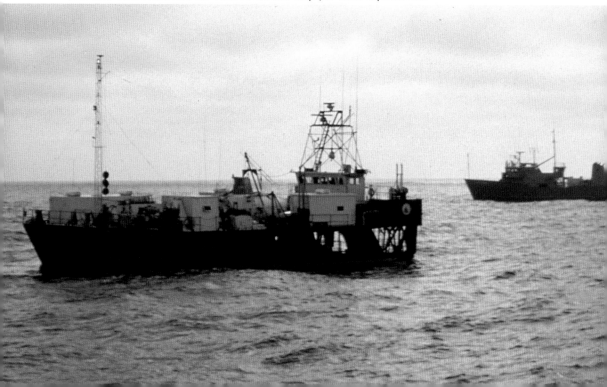

mersible to be used should be melted down into paper clips if the expedition failed.

The deep-sea geologists of Project FAMOUS wanted to see and study the Mid-Atlantic Ridge and its lava forms in person. They also wanted to study openings called rifts. They hoped to locate sea vents—openings created where the Earth's plates separate, causing cracks and fissures where seawater seeps in. As that water is forced back up through the openings, it should contain minerals from the rocks. Two of the expedition leaders were Robert Ballard of Woods Hole Oceanographic Institution on Cape Cod (and who later helped locate the *Titanic*) and Tjeer Van Andel from Oregon State University.

The area chosen to explore had plenty of activity. Before the dives, thousands of underwater photographs of the area were taken by a sled-toting camera. Some 5,000 prints were studied before the exact area for dives was selected, some 400 miles southwest of the Azores, islands in the Atlantic Ocean. The United States was to use the deep submersible *Alvin*. France employed their submersible *Cyana* and the bathyscaphe *Archimede*. All three were capable of reaching 10,000 feet (3,048 meters), more than adequate for the dives.

A Jumbled Mess

The dive site was dramatic. It was 20 miles long and from a half mile to two miles wide. Two volcanoes, Mount Venus and the 700-foot Mount Pluto were at the ends of two canyons. *Alvin*, with the Americans, concentrated on Mount Pluto and the French explored Mount Venus.

The scientists hoped they might find a clean seam where the Earth's plates met and see rivers of lava flows frozen in time. They

Hardened pillow lava comes in all kinds of shapes.

did not. Everything was a jumbled mess. The seafloor was torn apart with all kinds of faults and crevasses. There were massive blobs of hardened lava in all shapes imaginable—mammoth weiners, huge pillows, massive twisted basketballs. One scientist thought one section looked like a big baked potato with a crack on top, complete with a large scoop of sour cream.

After viewing a wall that rose almost a thousand feet, creating

a feeling of greatness and awe, Tjeer Van Andel said, "Your eye doesn't believe it."

Jim Moore, a U.S. Geological Survey volcanologist, agreed. "It was a geologist's dream," he commented.

By the end of the expedition, 44 dives had been made, 100,000 photographs taken, 3,000 pounds of lava rocks and countless sediment cores brought to the surface. One thing they had hoped to find—sea vents, the small holes spewing hot water—was missing. The French team did glimpse a small hole that may have been releasing hot water, but never could find it again. The spectacular discovery of seat vents would not happen this time.

3

Life from the Interior of the Earth

Some years after Project FAMOUS, another series of significant dives took place. The year was 1977. Months before, scientists from the Scripps Institution of Oceanography in California, from Woods Hole Oceanographic Institution, and from Oregon State University had discovered an area in the Pacific Ocean near the Galápagos Islands that gave off small temperature variations. Knowing there were temperature differences meant there had to be all kinds of deep-sea underwater activity. Perhaps they could locate one of the sea vents they knew had to exist along the ridges of the deep ocean.

The thermal activity, or temperature difference, was discovered by scientists aboard the research vessel *Knorr* towing a camera system called *Angus*, a two-ton camera sled. The camera was lowered by cable, along with a thermistor that could sense temperature changes up to 1/500 of a degree. When the probe passed over a

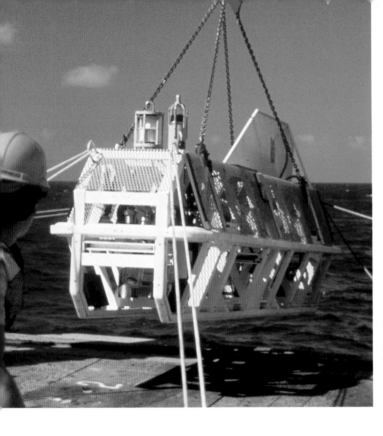

The Argo *is a sled-toting camera like the* Angus. *They are towed by Woods Hole research vessels.*

certain area and the temperature rose dramatically, they knew they had something.

The film was processed on board the *Knorr*. What the scientists saw on film was most unusual. They saw a field of huge clams. Clams by the hundreds were covering the lava in what was described as a thick blanket. Never before had so many clams been seen in such deep waters.

Later the *Alvin* was brought to the site to engage in a series of dives. What the divers saw in the light of the *Alvin*'s floodlights was an abundance of life—two-foot-long tube worms with red plumes, limpets, clams, crabs. In some way these creatures managed to live in the very warm waters of the vent area where there was no sunlight.

Samples of water and rocks were brought to the surface from

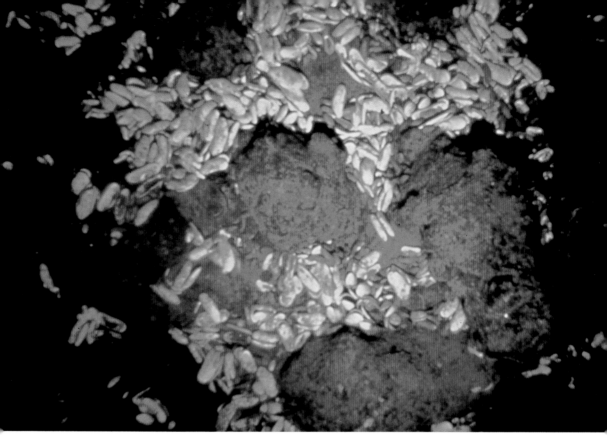

Above: Clams found at a vent site. Below: Colony of tube worms on vent sulfides.

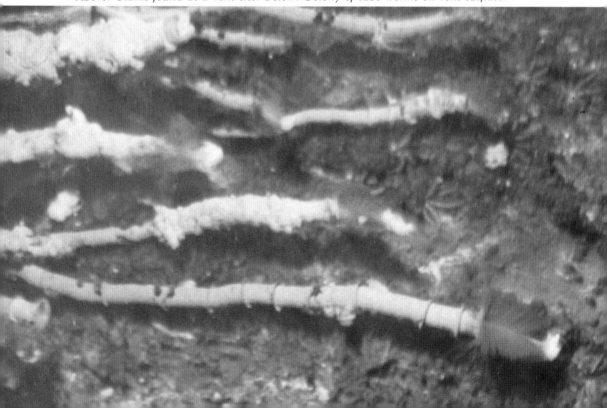

this vent area they named Clambake I. When scientists aboard the *Knorr* opened up the containers with the water samples their noses were hit with a peculiar but familiar smell. It smelled like rotten eggs, which meant the presence of hydrogen sulfide.

The project scientists, led by John Corliss of Oregon State University and Robert Ballard of WHOI, felt that finding hydrogen sulfide was proof that seawater did seep into the ocean crust and return much hotter and loaded with minerals. They knew that water has, among other properties, sulfate. When sulfate was heated by the hot lava seeping up in the vent area and was also under extreme pressure, it changed to hydrogen sulfide.

Then, for the first time, some of the strange new clams, crabs, and tube worms were brought to the surface. What the scientists were still to learn was amazing. It was known that bacteria were to be found in all the seas at all depths. When certain kinds of bacteria came in contact with the hydrogen sulfide, they were able

Crab, clam shells, and tube worms at a vent site.

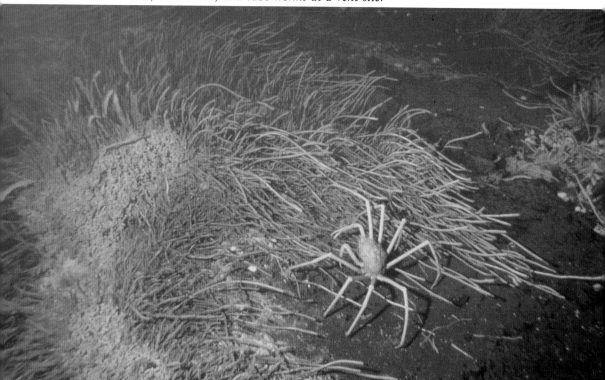

to use it to multiply. With millions of these bacteria living in the vent area, it allowed the clams and crabs and other life forms to feed off them. Here was a new form of life not known before. These creatures did not rely on the sun as a source of energy.

Photosynthesis

Up until this time it was believed that all life on Earth was supported by the sun and only the sun. The energy of the sun, transported by sunlight, is used by green plants to grow. They change light energy into chemical energy through *photosynthesis*, a complicated process using water and oxygen. Animals such as cows, horses, people, insects, and fish feed off plants, either directly or indirectly. Their energy can be traced to the sun. Even ocean animals live off each other or on food that drifts down from the surface, and thus depend on the sun.

Clams are usually plentiful at vent sites.

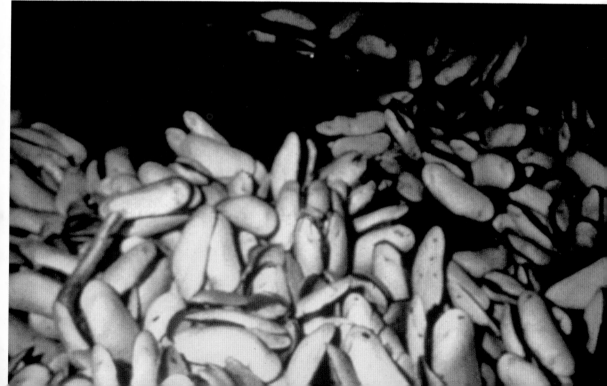

Chemosynthesis

The newly discovered life process is different because no part of it is relying on the sun's energy. Hydrogen sulfide, coming from within the earth, is the energy source. In its pure form, hydrogen sulfide is deadly to most living things, but bacteria at the hot vents actually thrive on it. Like green plants, the bacteria form the first link in this new food chain.

Imagine what the deep-sea explorers and all other scientists were thinking when the news of a new life form spread around the world. It was previously thought that the lack of sunlight would prevent any life at the bottom of the oceans. And it was believed that life could not exist where it was hotter than the boiling temperature of 212° Fahrenheit (100° Celsius). But vent bacteria are unusual. Even when the water gets to 400° F (204° C) or more, they thrive.

Bacteria can be put into three groups: harmless bacteria, harmful bacteria, beneficial bacteria. Fortunately, the harmless bacteria comprise the largest group. They are found everywhere—in the earth, on rocks, floating in the air, even in our bodies. Harmful bacteria cause food to spoil, infectious diseases, sickness and even death. Beneficial bacteria are used to make cheese and yogurt, to make linen cloth, to help turn animal hides into soft leather.

Vent bacteria are certainly beneficial for the animals that live near vents. Scientists would like to determine if vent bacteria could live on the surface and feed on the sulfides that add to toxic emissions spewing from smokestacks when factories burn coal and oil. Even if the chimneys of one oil refinery could be made cleaner by the bacteria, it would be worth trying the experiment.

4

Black Smoker Chimneys

There were more expeditions and more dives. One place was called the Garden of Eden. Scientists were surprised but delighted to see many kinds of animals living in the warm water at vents where the water temperature was measured at 54° F (12° C). There were beds of tube worms, delicate anemones, crabs, mussels, eel-like and colorless fish, and all kinds of snails and more giant clams. In other vent areas named Dandelion Patch and Oyster Bed were colorless crabs, smaller clams, and animals that looked like dandelions that had gone to seed. There were long, thin organisms that reminded the submersible divers of spaghetti but were later identified as acorn worms.

Samples and photographs of animals that lived off the hydrogen sulfide bacteria were brought back. Clams and rocks were gathered by using *Alvin*'s collecting arm. The samples were placed in baskets attached to the hull of the submersible. Seldom was there a need

to catch any crabs. Divers reported that the crabs crawled all around the outside of *Alvin* and attached themselves in every crevice and cranny. Upon reaching the surface, the crabs were dead, as were other animals not in pressure capsules. They died because of the tremendous changes in pressure and temperature of the water. Still, biologists examined them and got a good idea of what they were like.

Anemones and sulfide deposits at vent site.

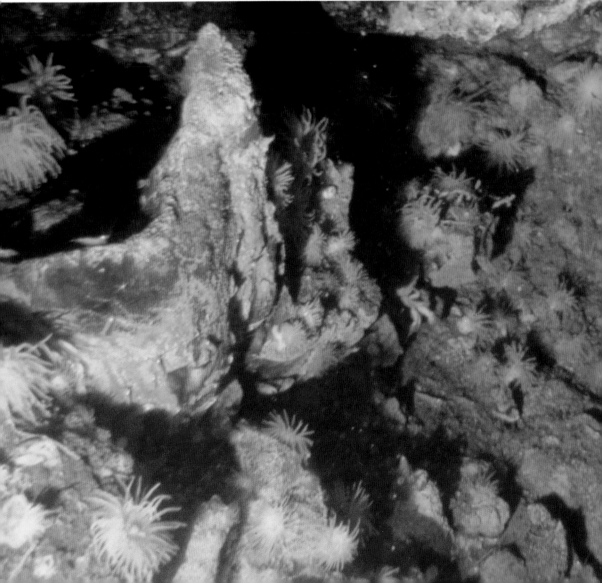

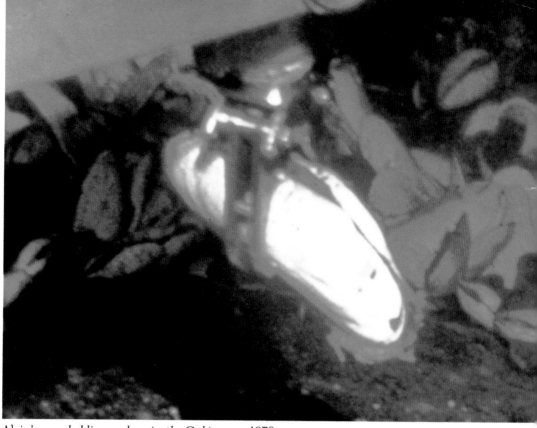

Alvin's *arm holding a clam in the Galápagos, 1979.*

The First Black Smoker

In 1978, United States, Mexican, and French divers aboard the French expedition submersible *Cyana* dove to the East Pacific Rise at an area referred to as 21 N. off the coast of Mexico. The results of those dives were much different. They found evidence of vents that were inactive, and giant clams that were all dead in an area called Clambake II. The clams were similar to those found at the Galápagos Rift in 1977.

The next year, in January of 1979, came another exciting discovery—a black smoker chimney. A dive was made at the East Pacific Rise at the juncture of tectonic plates known as the Pacific plate and the Cocos plate. The purpose of the dive was to sample

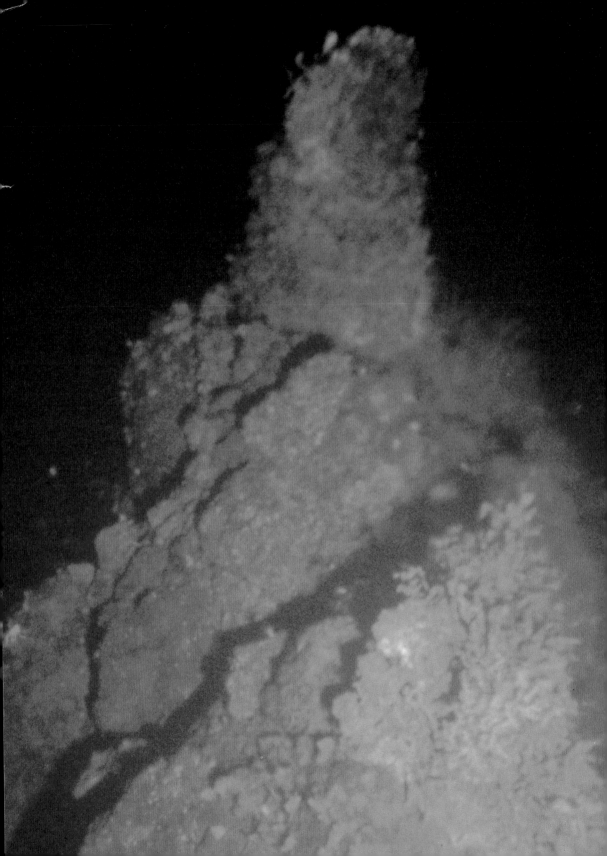

three hydrothermal vent areas that had been recognized in photographs. Three men were aboard the *Alvin*—pilot Dudley Foster, marine geologist William Normark, and French scientist Thierre Juteaux. They were four hours into the dive at a depth of about 8,500 feet (over 2,500 meters) when they came across something never seen before—a black smoker chimney.

The chimney was black and spewed out plumes of hot water and black clouds of minerals. The minerals, coming from below the surface of the seafloor, formed the chimney around the vent opening. The chimney, or black smoker, was about six-and-a-half feet (nearly 2 meters) tall. The *Alvin* passed over the chimney and attempted to take a temperature reading with its thermal probe. It was not possible because the probe could measure only up to 35° C (95° F). Part of the probe melted and the plastic reinforcing rod taped to it was charred black.

Dudley Foster had seen just about everything in reference to the geology of the seafloor, but this was so new he was overjoyed. It was the first-ever black smoker chimney, since not all vents have chimneys. In order to collect a sample to take to the surface, the *Alvin* was used as a kind of battering ram to knock over the chimney. A section of the middle was collected by the arm and brought up to the mother ship and eagerly awaiting scientists.

Later it was discovered that the temperature of the water at the opening of the smoker chimney was estimated to be 650° F (343° C) or perhaps higher. Finding water that hot was also rare. Water at the surface reaches 212° F (100° C), then boils and turns to steam. Water heated by the magma below the seafloor goes way

Black smoker chimney. The first one ever seen was discovered in January of 1979.

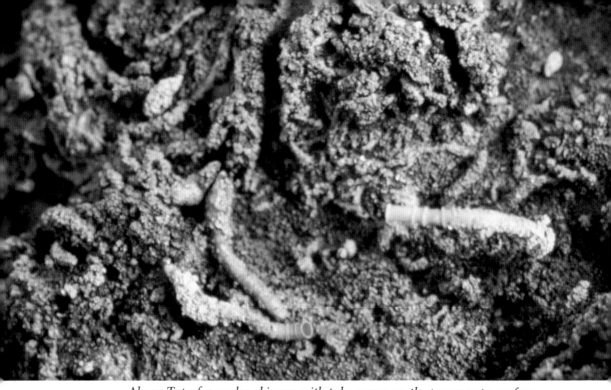

Above: Top of a smoker chimney with tube worms on the porous outer surface.

Below: Ridges of a smoker chimney and shrimp.

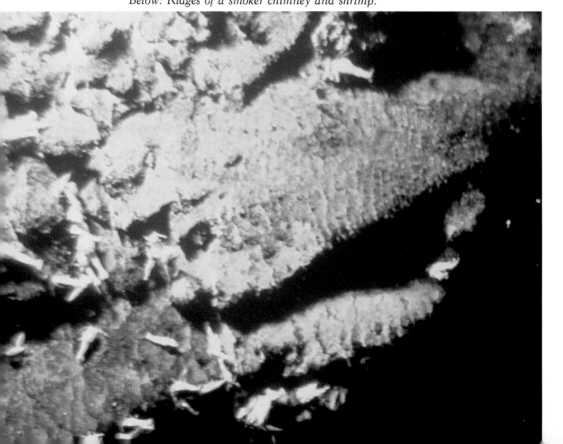

beyond the surface boiling point because the water is under such great pressure. Seawater does not boil until it reaches higher temperatures than 212° F (100° C). Therefore, it gets much hotter than boiling water does at the surface.

Black smokers have been found at other vent sites since that first one was spotted. They are hollow structures and some reach a height of 20 feet (6 meters). Openings are small, from a half inch to four inches across. Fluids pouring out of the openings are extremely hot, reaching 300° C or more (over 570° F). Black smokers emitting fluids have been found at almost all of the functioning vent areas.

Vent sites vary in size. Those with black smoker chimneys are from about 33 feet (10 meters) in diameter to about 650 feet (200 meters) in diameter. Often the vents are atop mounds of various sizes. The largest mound located so far was found on the Mid-Atlantic Ridge at 26° N. It is known as the TAG (Trans-Atlantic Geotraverse) mound. The black smoker chimneys are scattered on top of the TAG mound that is from 33 to 65 feet high (10 to 20 meters). How the TAG mound grew to such size is not yet known, but is under study.

View of Alvin's *basket with large fragment from a black smoker chimney.*

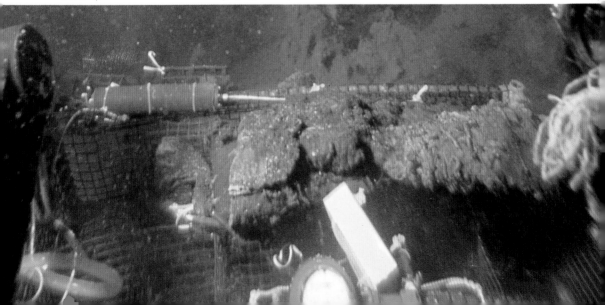

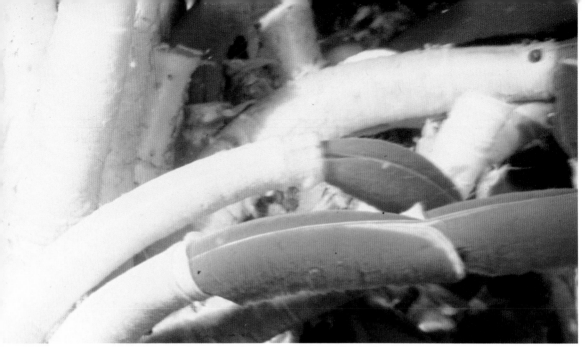

Above: Tube worms from 1979 dive in the Galápagos.

Below: Tube worms in bucket on deck of support vessel.

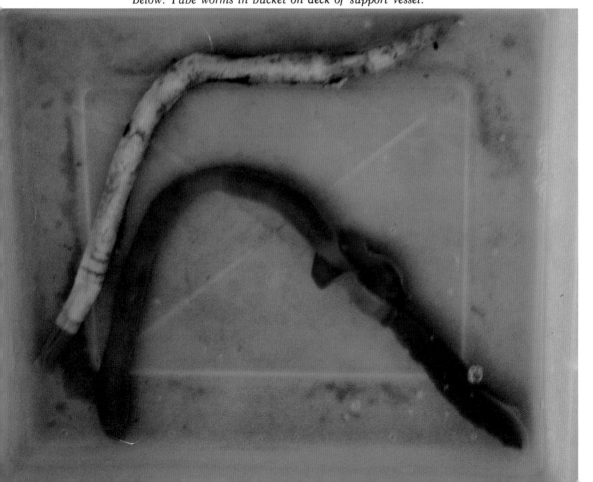

5

Deep-sea
Vent Life

Deep-sea vent animals were brought to the surface in pressurized chambers and installed in various laboratories for research. They were studied at length.

There were three kinds of giant tube worms, some six feet long. It was determined that the worms consisted of four distinct parts. There was the head end sticking out of the tube. It was red, the color coming from hemoglobin in the worm's blood. Beneath the head was a collar, and below that was the trunk that was the main part of the body length. A fourth part anchored the tube worm to the seafloor.

The tube worms had no mouths or guts. Their food or energy came from bacteria found within the worms. Scientists concluded that the tube worms got most if not all of their nourishment from bacteria that was actually living within their bodies.

There have been at least 48 species of deep-sea vent mollusks

recognized—clams, mussels, limpets, and what could be called snails. Mollusks have been found at most vents in both the Atlantic and Pacific rifts.

Some of the mollusks have an ability to grow very fast and very large. Some clams brought up were several inches to a foot in length. Yet some of the clams grew at a rate similar to shallow-water mollusks. It was believed that some of the vent clams and mussels had longer lives than those living nearer the surface. A warm-water surface mussel may grow and live from five to seventeen years. A deep-water vent mussel was estimated to be at least twenty-three years of age.

Giant vent clam next to ball-point pen to show size of clam.

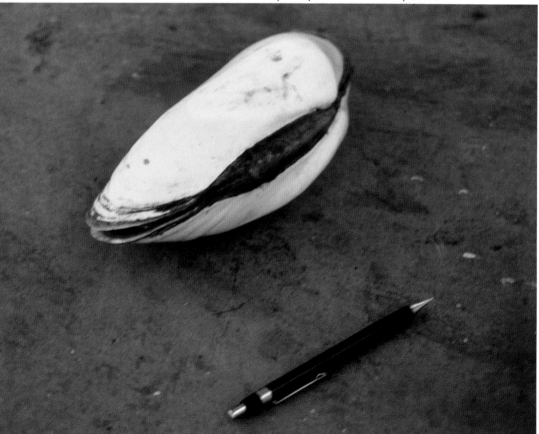

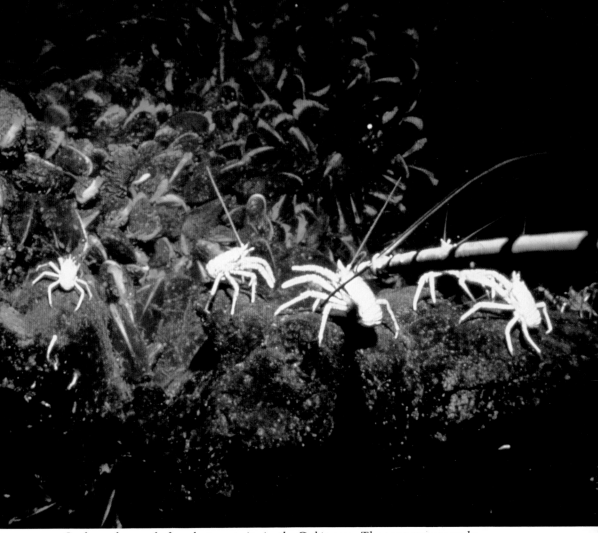

Crabs and mussels found at vent site in the Galápagos. The temperature probe records the temperature of the water.

When scientists opened up a large clam, they found that it had red flesh similar to that of large tube worms. And the large clam also used bacteria within its own body in order to live. Surface clams have a siphon, and as they take in seawater, microscopic food is obtained from the water. Vent clams have no such siphoning equipment.

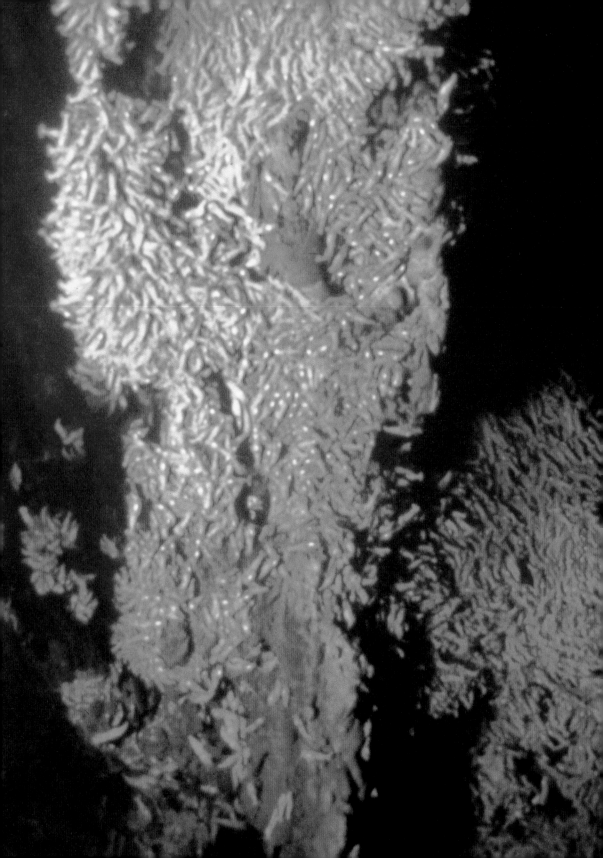

Vent shrimp were of particular interest. Smoker chimneys would be almost covered with shrimp, so there were plenty of shrimp samples. At first it was thought that vent shrimp had no eyes. In fact, they were named *Exoculata*, meaning "without eyes." There were no eyestalks or corneas usually found on shrimp. Because there was no light where these shrimp lived, scientists assumed there was no need for eyes.

Pacific vent shrimp seemed to have normal numbers and lived within the vent colony with other animals such as anemones, fish, and snails. Atlantic vent shrimp differed by their huge numbers. A square yard held as many as 1,500 shrimp, almost obscuring the surface to which they clung. The Atlantic shrimp were also observed grazing on the sides of the black smoker chimneys. The chimneys were covered with sulfides and the shrimp, with claws shaped like scoops, were equipped to scrape off the sulfides. The claws picked up pieces and swept them into the shrimp mouths. Shrimp examined in a lab had their stomachs loaded with sulfide. Within the sulfide were live bacteria which provided food for the shrimp.

A woman scientist, Dr. Cindy Lee Van Dover of Woods Hole Oceanographic Institution, studied videotapes and photographs of the shrimp. She noticed a spot on the back. On examination, it was learned that the spots were lobes, and each lobe was connected by a large nerve cord directly to the shrimp's brain. After exhaustive study it was determined that these spots were a type of compound eye. The eyes could not see images, but they could detect light. Van Dover and others asked themselves, what light is there in the deep, dark sea? Also, if there was light, where did it come from?

Shrimp swarming over a smoker chimney at the Mid-Atlantic Ridge.

Is There Light Down There?

Dr. Van Dover concluded that there must be some form of light coming from the vents. If there was light, then the shrimp could use their eyespots to guide them to the vents. However, as in any kind of science, she needed proof. Help came from another scientist who was to use a camera in a deep-sea vent study that would be sensitive enough to detect levels of light that the shrimp might see.

Van Dover joined a research trip to a dive at the Juan de Fuca Ridge site off the coasts of the states of Washington and Oregon. She was not to be one of the divers herself, and was forced to stay topside, nervous and excited, waiting to find out if her hypothesis was correct.

There were many dives at the site and on the last, the nineteenth, the camera would attempt to photograph vents to see if they glowed. Van Dover sent messages to the *Alvin* below, but got back only busy signals. Finally, the dive was over and the submersible was heading up, an hour-long ascent to the surface. Still there was no word from the crew, so she left the communications room. Later she returned and was handed a note sent to her from the *Alvin* crew. It was a simple message: Vents glow. It was exciting news, though she knew that it would take a lot more dives and a great deal more study to explain why there was light at a vent.

6

New Discoveries, New Ideas

Although Cindy Van Dover did not get to dive when her hypothesis about glowing vents was investigated, she was an experienced diver and had made many other descents. She realized that if she wanted to go down to deep-sea vents, the best way to get more dives would be as a pilot. At first she was on the *Alvin* as an apprentice to train to be a pilot. It was an exciting day when she completed that training and was handed her pilot's license. It was number 49. The previous 48 licenses had all been given to men.

It is not easy for marine scientists to get where they want to go, especially if it is down where deep-sea vents are found. A scientist may have the money to pay for the dive, and assistants ready and willing to support the mission. But is there a submersible available? Probably not. There are only a handful of deep submersibles in the entire world capable of reaching 12,000 feet (over 3,650 meters).

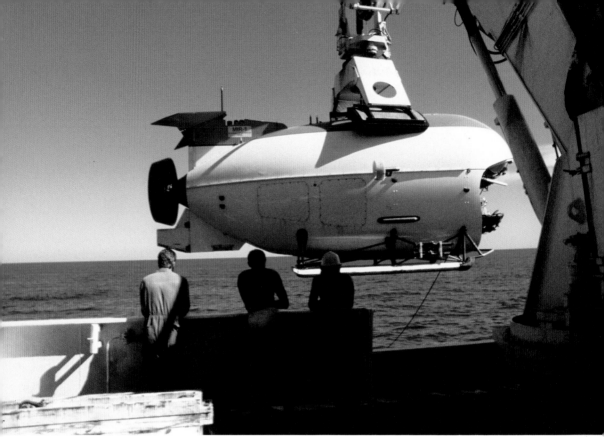

The Russian submersible Mir

There are two Russian submersibles, the *Mir* (*Peace*) I and II, the U.S. Navy's *Sea Cliff*, and the French *Nautile*, in addition to those already mentioned.

A scientist may have to wait years to get on a dive, if at all. First, a proposal has to be written, then a committee of scientists reads it and discusses it. They decide if the proposed dive is worthwhile. If not, there is no dive. One woman scientist waited eleven years to dive to the sea vents. However, she said the wait was worth it because it was so very exciting when she finally reached the dark and mysterious seafloor.

After visits to the vents, it would have been easy for scientists

to assume that it was the fire beneath the sea and the creation of hot sea vents that was the basis for this new form of life. However, as in all science, there are always questions raised, new ideas presented, arguments set forth. A few scientists had the idea that maybe the hot sea vents were not the sole reason for this newly found life. Proof was needed, and then in a new dive on a new day in a different ocean there was indeed something new to consider.

Something Different

It was the Florida discovery, and it caused excitement and further thinking. In March of 1984, something totally surprising was found in the abyssal Gulf of Mexico. Dives were made aboard the *Alvin* and the divers came across communities of organisms more than 10,000 feet (3,048 meters) down. There were mats of bacteria that

Fish brought up from a vent site.

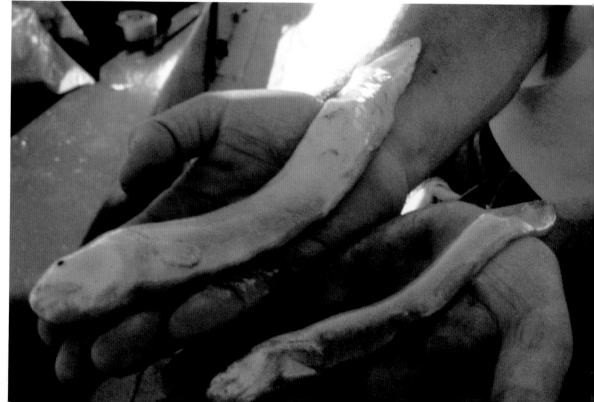

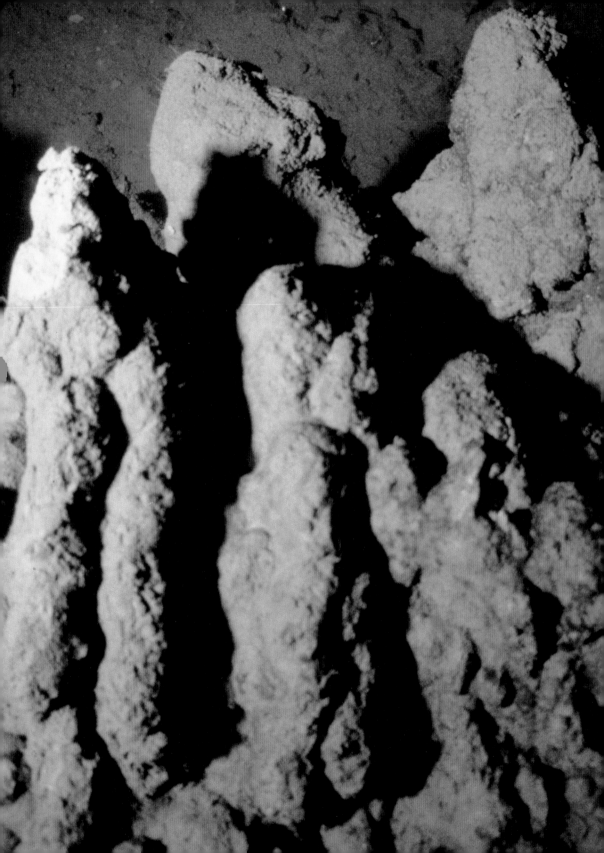

seemed white under the lights of the submersible. There were patches of tube worms, giant clams, the same crabs, mussels, eel-like fish, and snails that had been found before. At first it seemed to be a typical vent community like those at the mid-ocean ridges where magma oozed. However, that was not what was found.

The Gulf dive was at an area called a continental margin and not a ridge. What was not present was a hot spring or vent. Still, there were all the same animals. They were at the base of a huge limestone cliff 6,500 feet (1,981 meters) high. (That is about a mile and a fifth high.) What was occurring was a seepage of very salty water, along with sulfide minerals. Bacteria flourished and in so doing supported the animals feeding off them. But there was no superheated water. In fact, the water was quite cold. Scientists concluded that communities of animals exist without sunlight in areas without heated water and in other places than mid-ocean ridges. They called this new kind of area a "cold seep."

The Origin of Life

After an unspecified time, the hot deep-sea vents stop spewing hot water and minerals. The animals that depend on them produce many offspring and some of these may be lucky enough to be carried by currents to another active vent. If not, they die off, but scientists believe that the different kinds of vent animals have been in existence for millions of years.

That such complex forms of life can exist without sunlight has led to new questions about the origin of life on Earth. Up to now,

Sulfide knees at vent site called Gorda Ridge off the coast of Oregon.

it was believed that all life began with the sun's energy as the source. Through photosynthesis, that sun energy was used by plants and animals to reproduce. Now a new theory exists. Perhaps the geothermal energy at the deep-sea vents gave rise to primitive organisms like the bacteria found there, and perhaps that was where life first began.

Only a very small part of the globe we know as planet Earth has been explored in detail. For example, in the summer of 1992 an additional life form was discovered by scientists from Woods Hole. Small shrimplike animals were found at a vent site 8,250 feet or 2,515 meters below the surface. The animals, similar in appearance to beach fleas, live in swarms of 5,000 to 50,000. Cindy Lee Van Dover, one of the scientists aboard *Alvin*, described them as "like a swarm of gnats underwater."

The discussion of the origin of life on Earth will go on for decades to come. The discovery of life at deep-sea vents has opened up new thinking. There will be many more dives, many more discoveries, and many more debates.

Close-up of worm found on smoker chimneys in the East Pacific Rise.

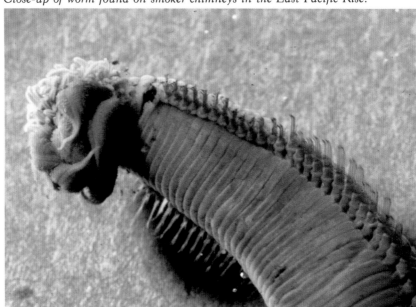

Index